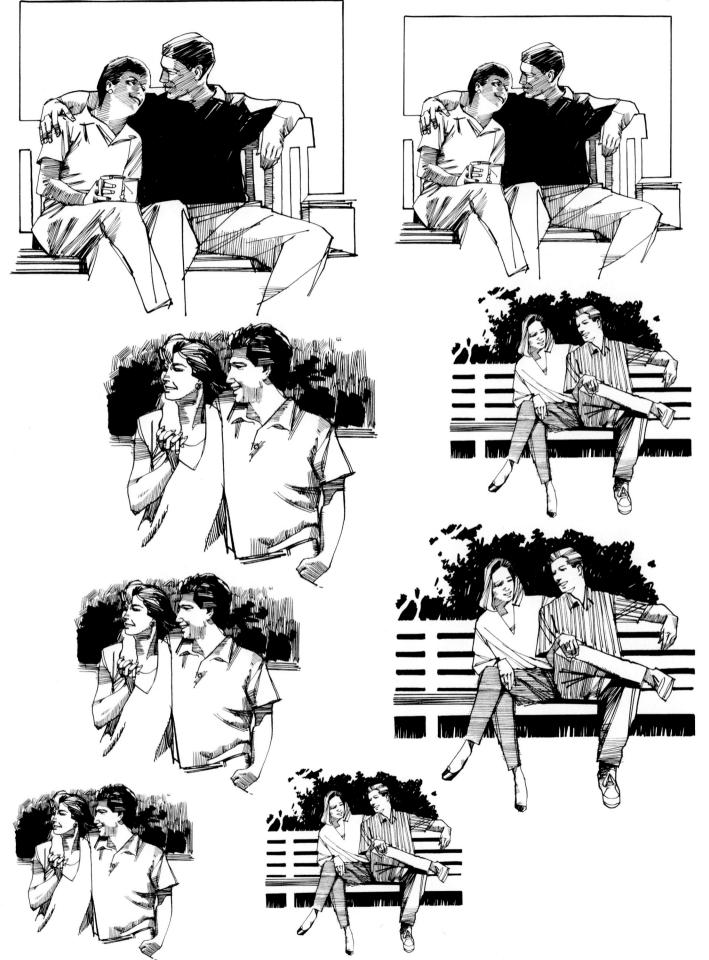

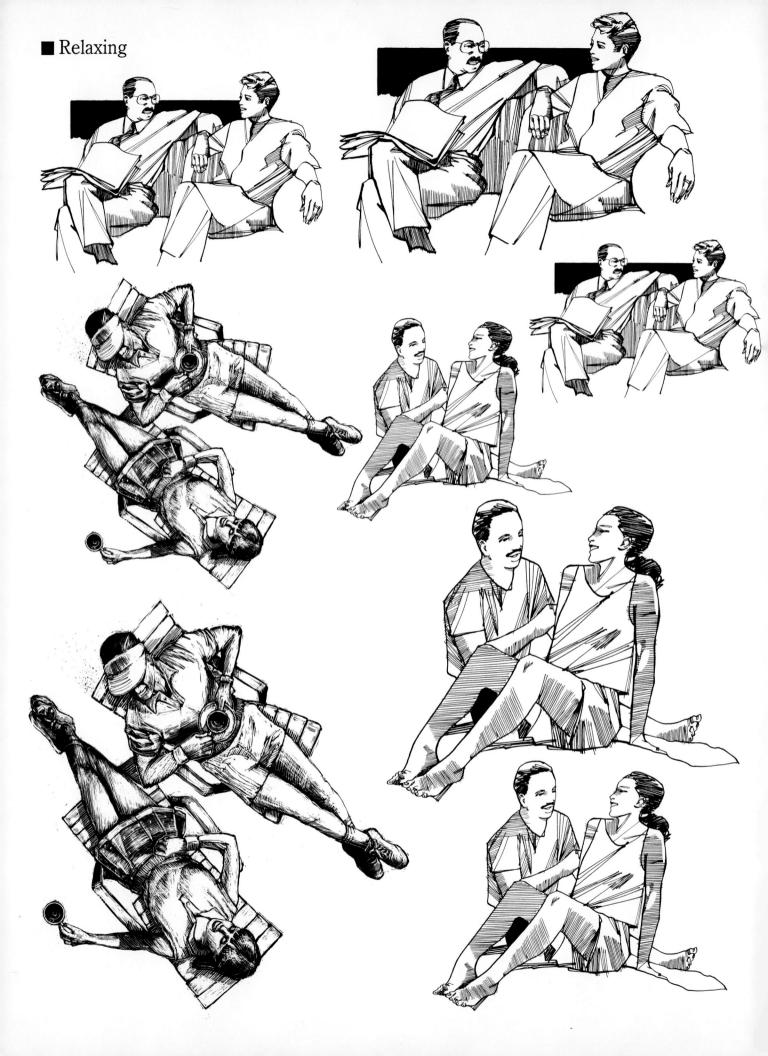

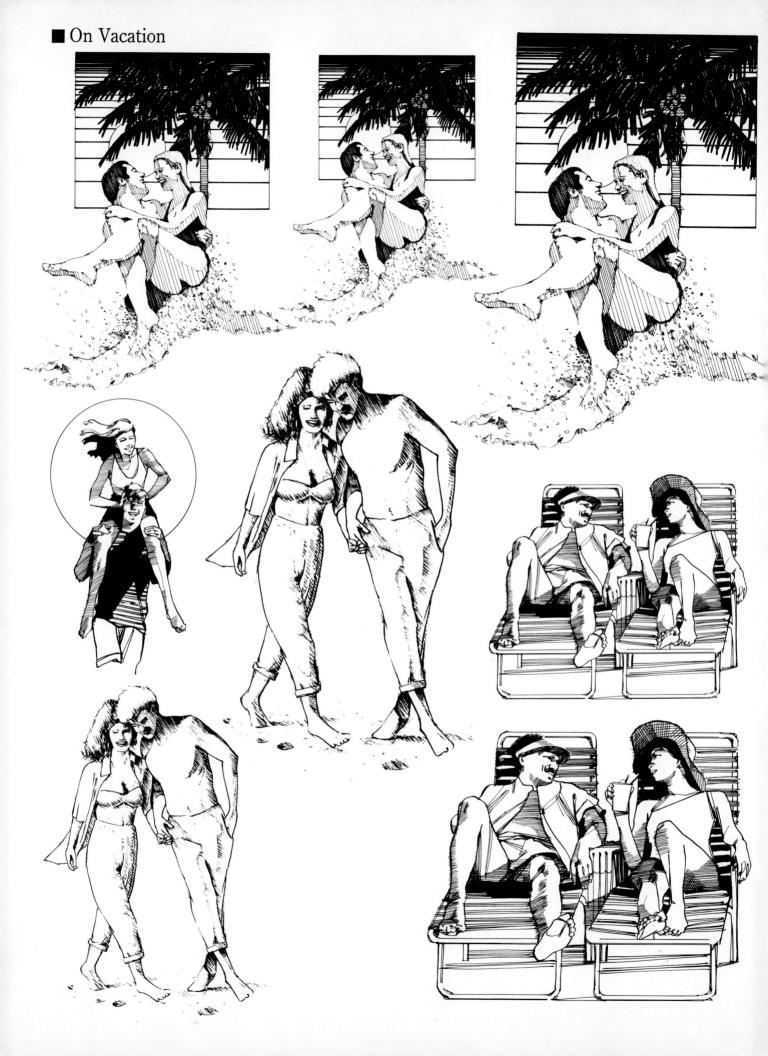

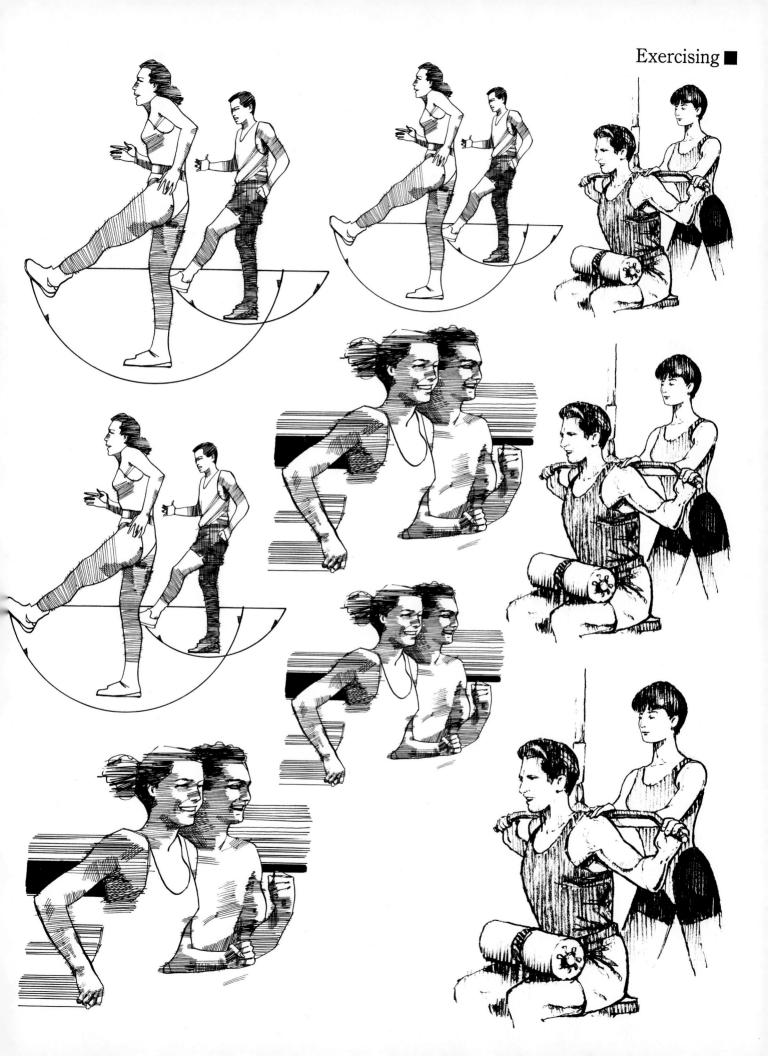

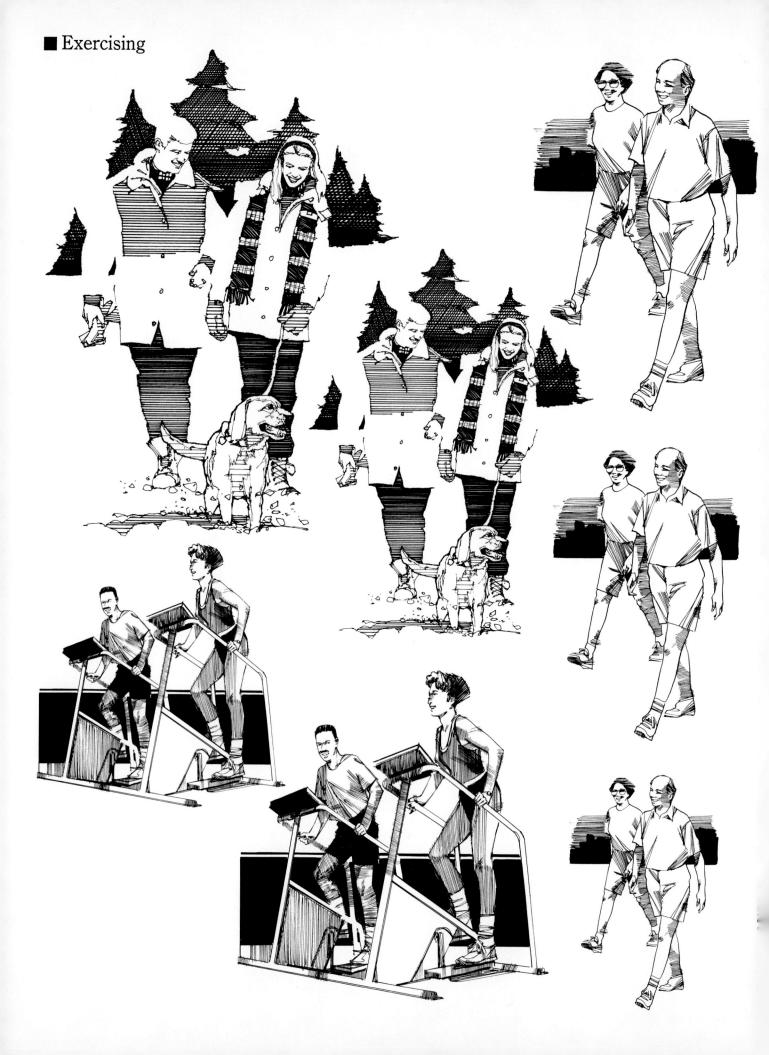

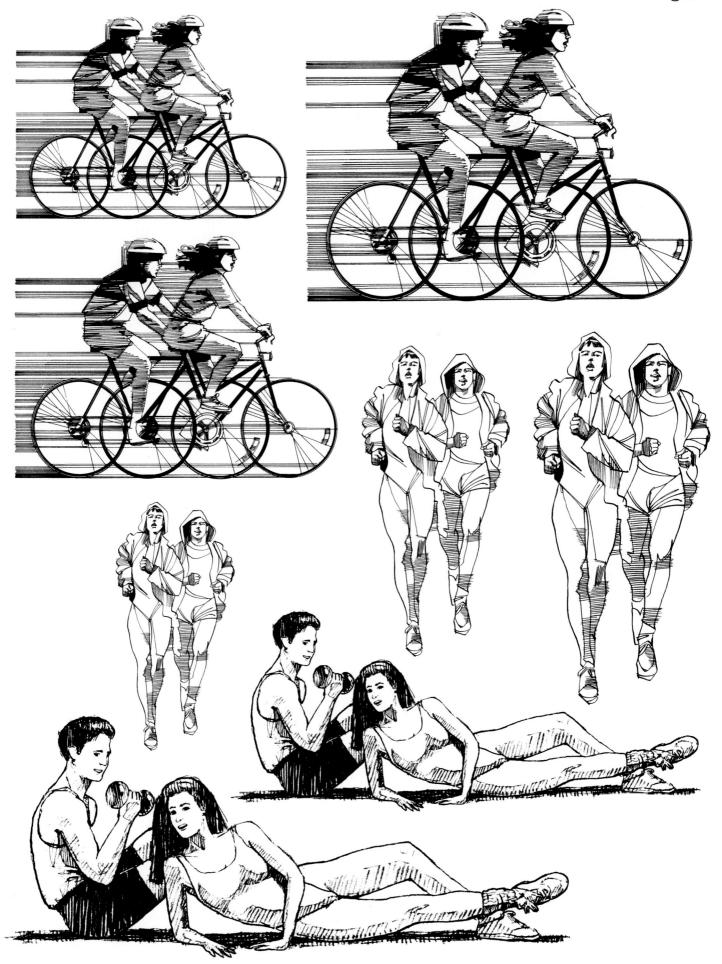

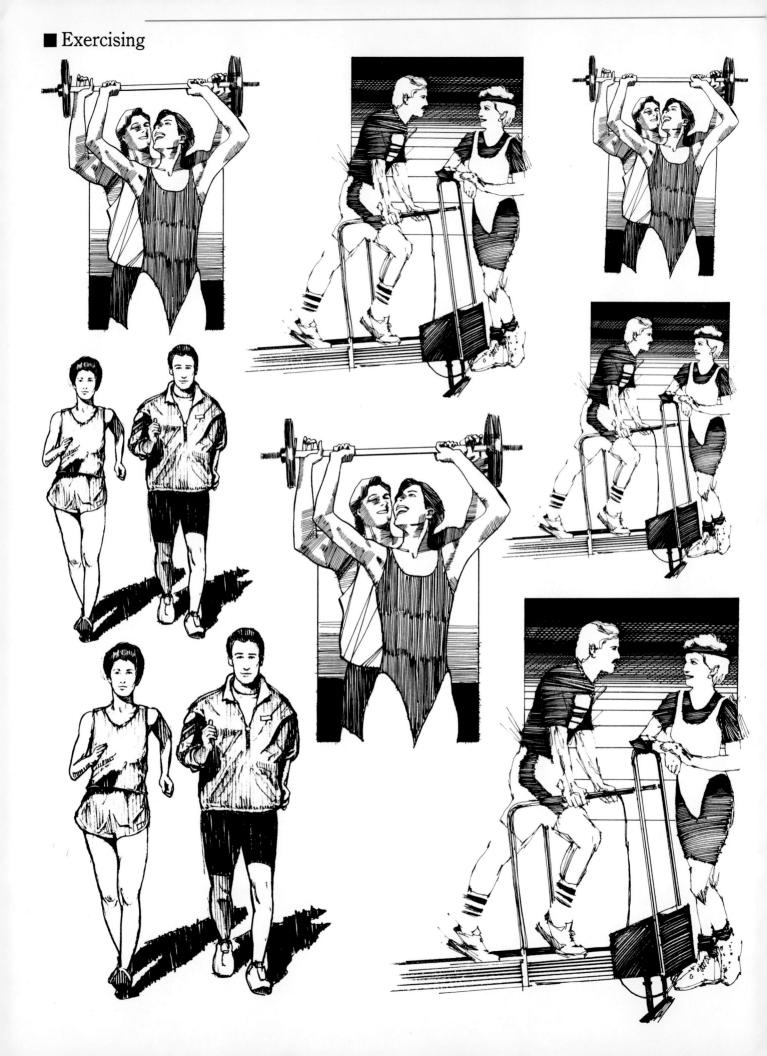

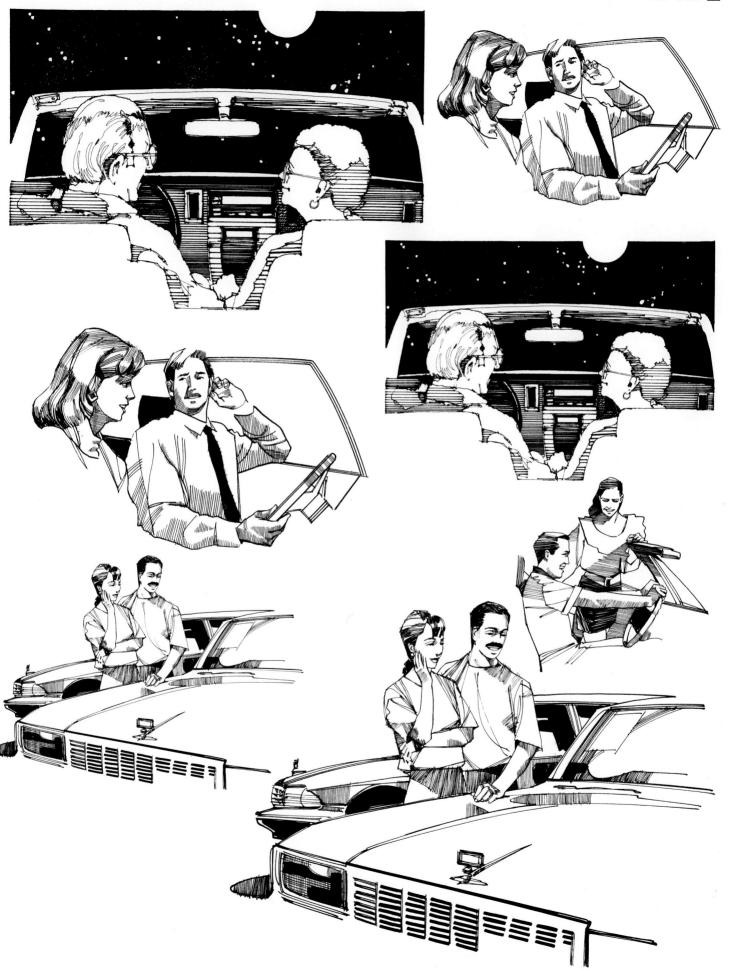

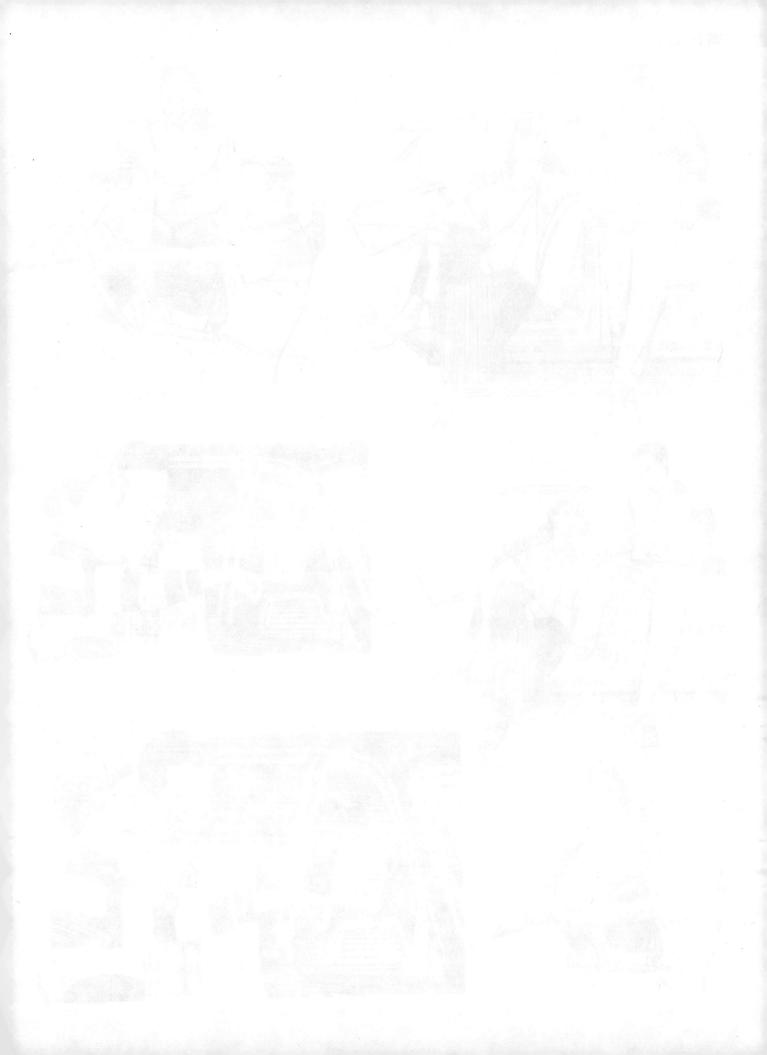

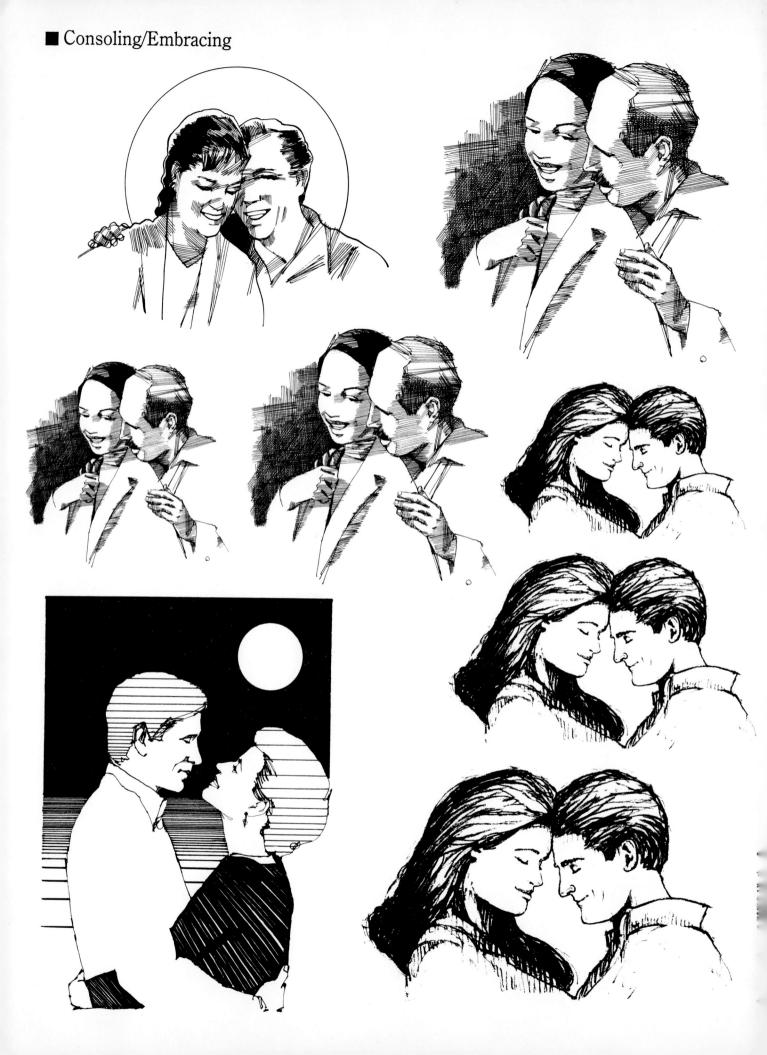

Consoling/Embracing ■

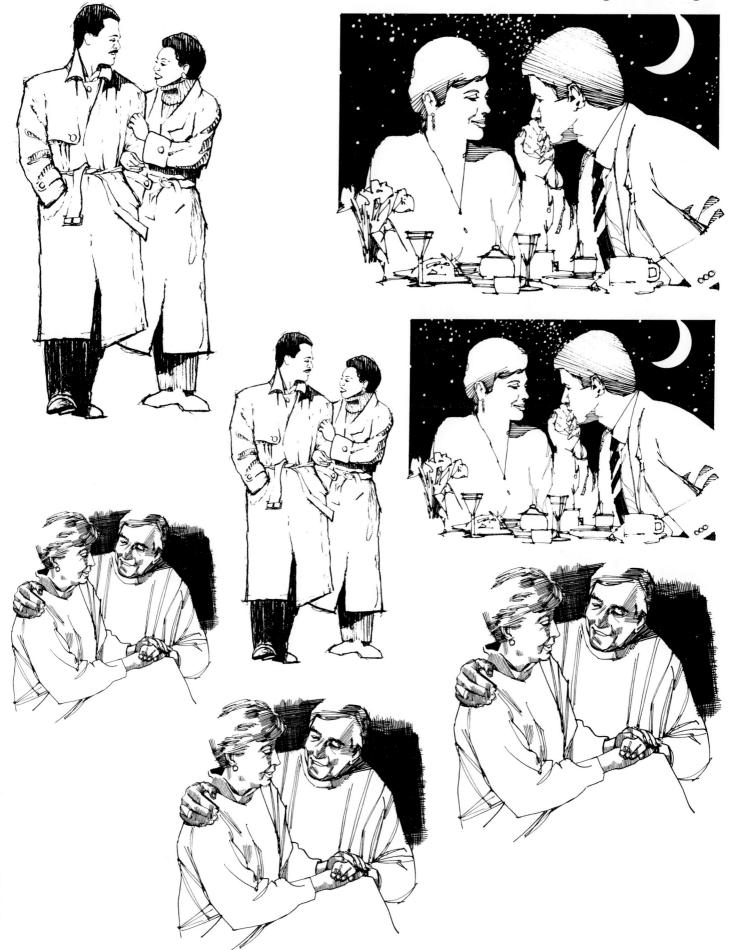

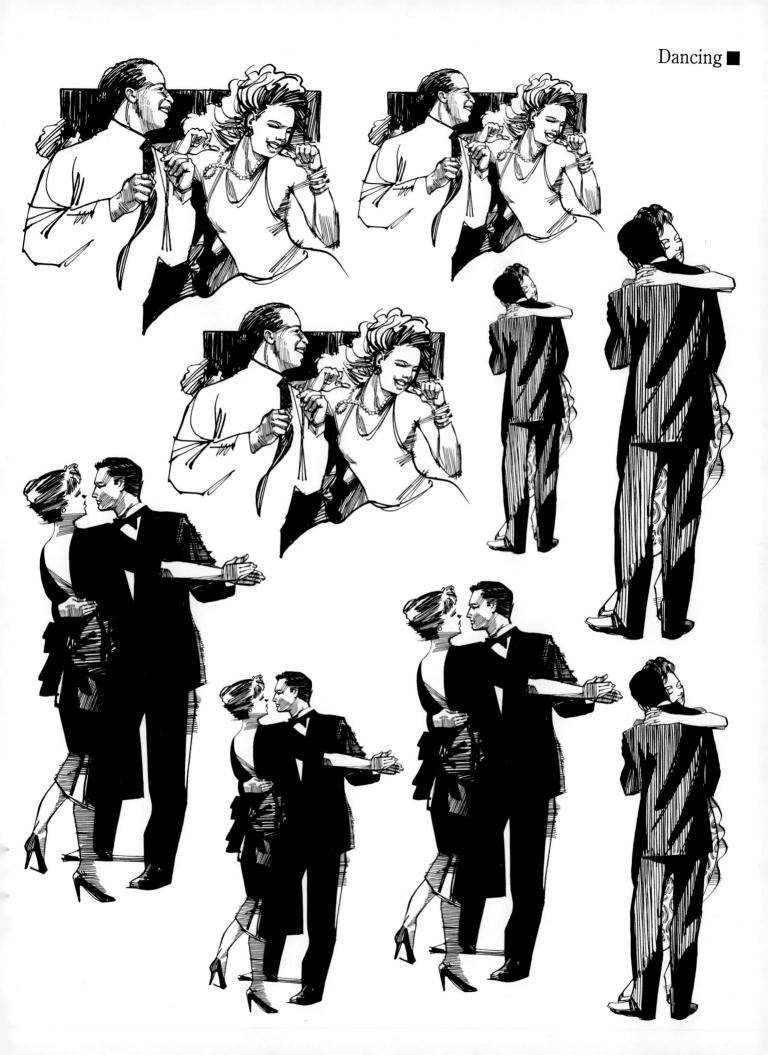

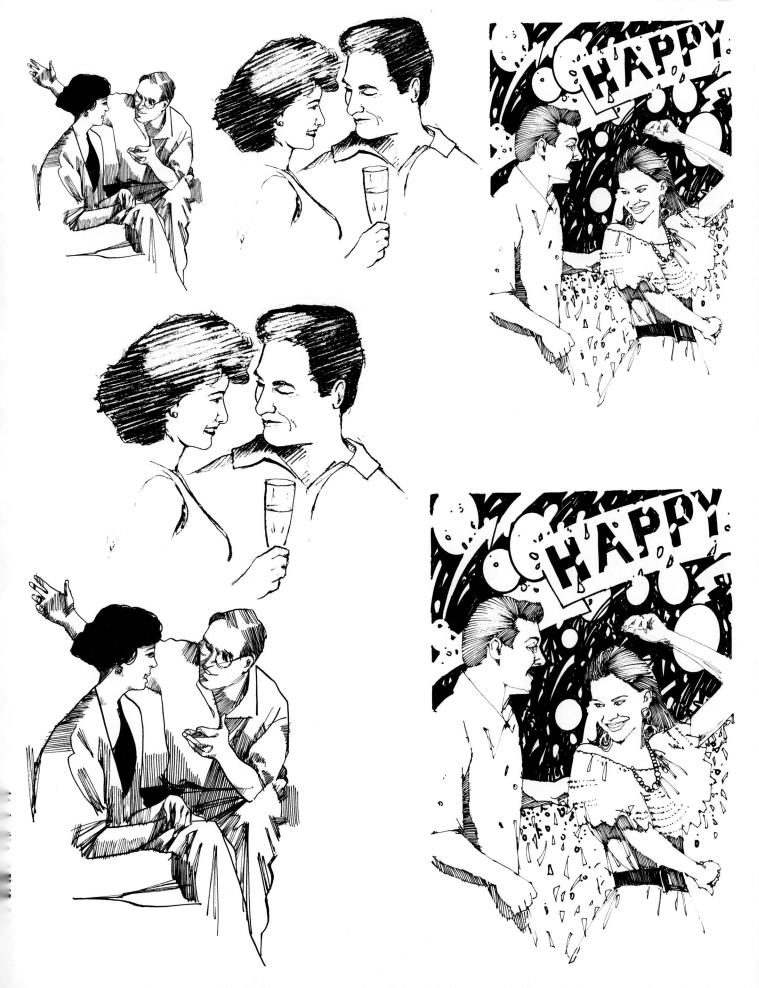

■ Parties

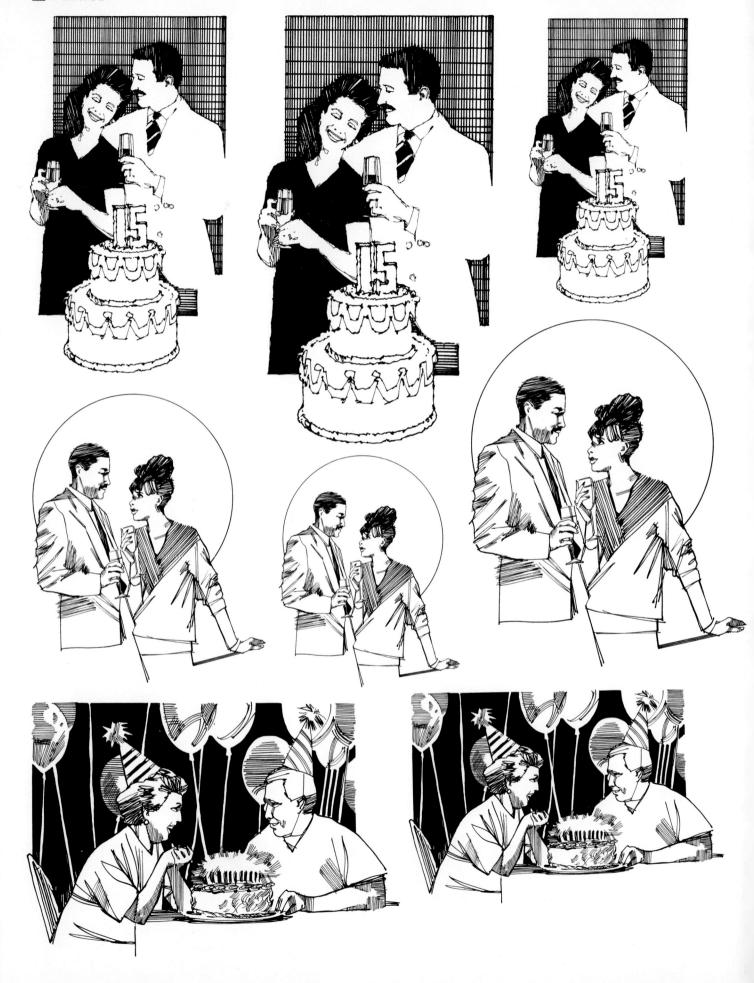

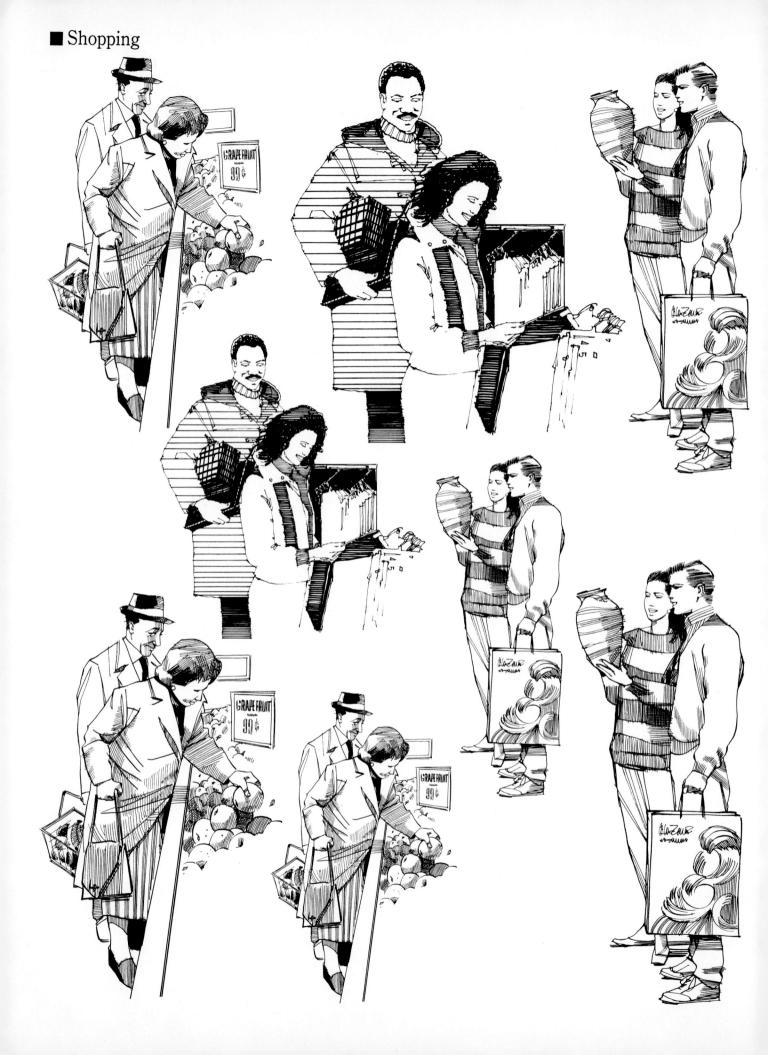

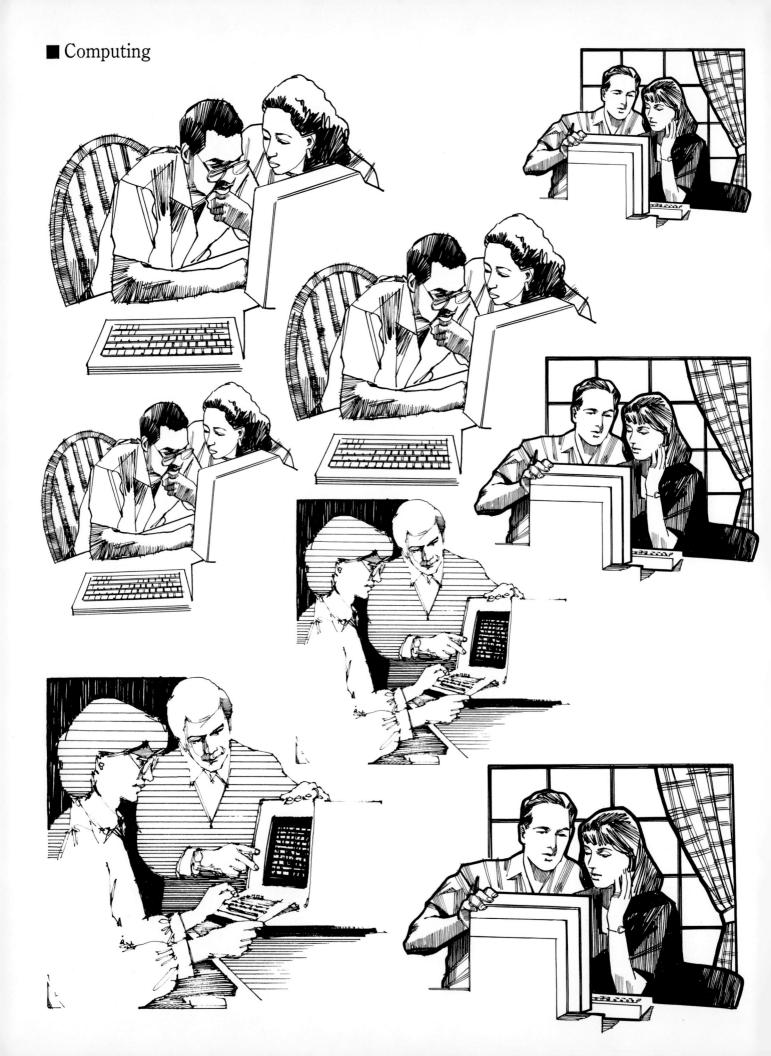

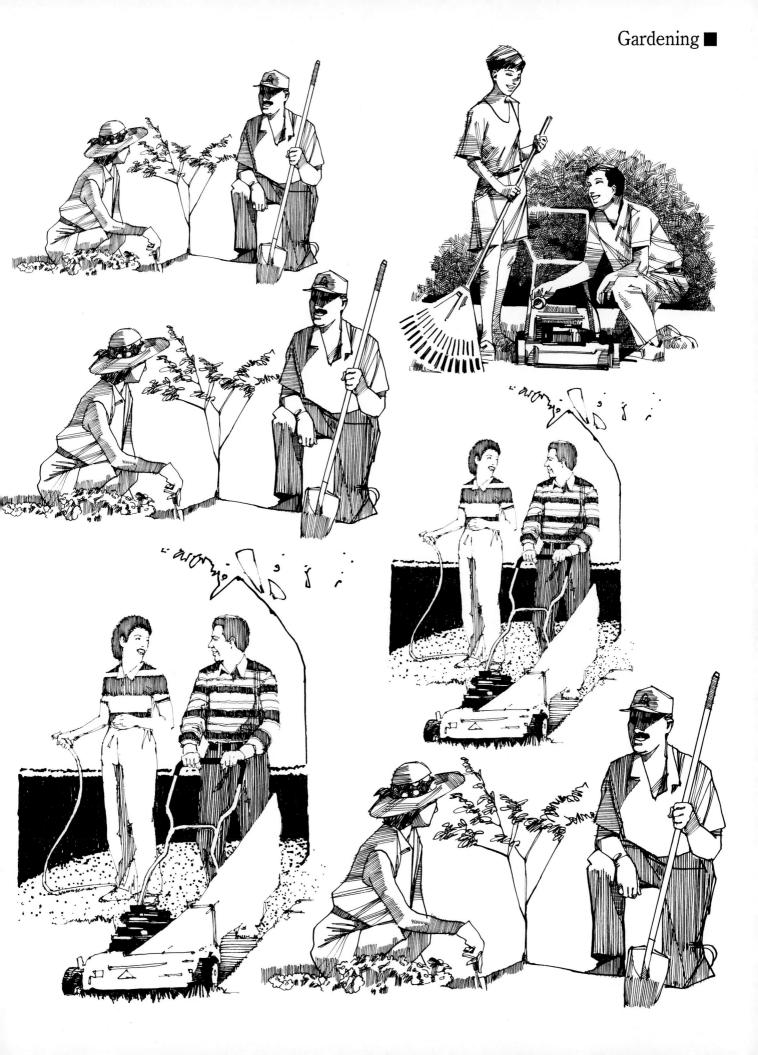

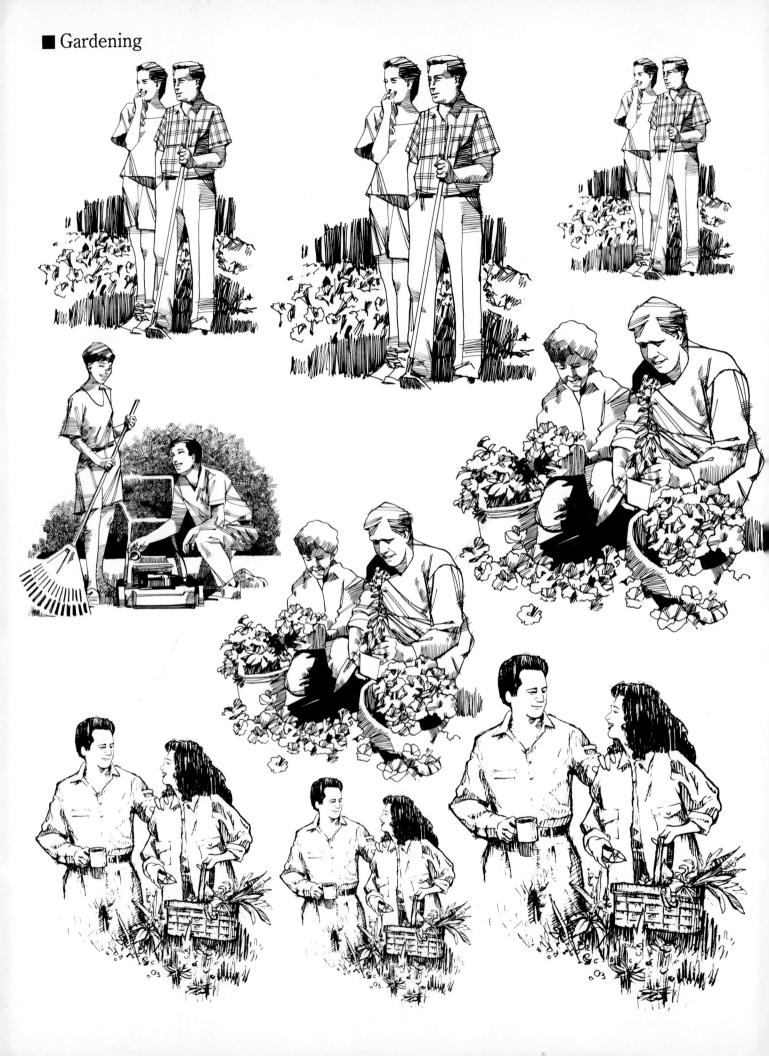